soul mates

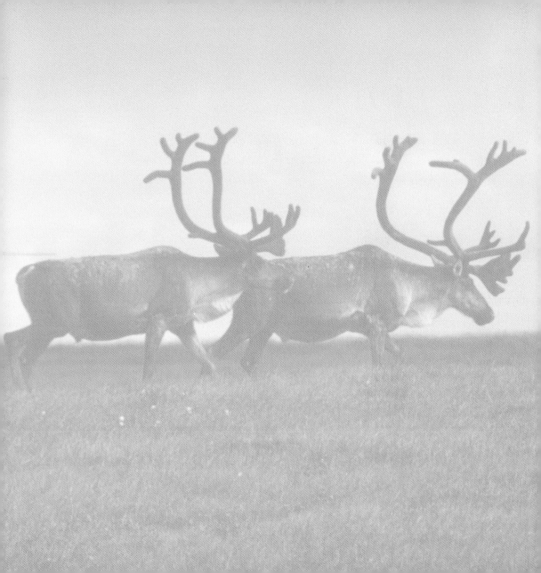

soul mates

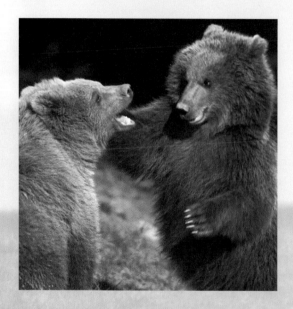

love's magic moments

edited by tom burns

BARRON'S

First edition for North America published in 2006
by Barron's Educational Series, Inc.

All inquiries should be addressed to:
Barron's Educational Series, Inc.
250 Wireless Boulevard
Hauppauge, New York 11788
www.barronseduc.com

Library of Congress Control No: 2005935920

ISBN 10: 0-7641-5987-9
ISBN 13: 978-0-7641-5987-9

Conceived and created by
Axis Publishing Limited
8c Accommodation Road
London NW11 8ED
www.axispublishing.co.uk

Creative Director: Siân Keogh
Designer: Simon de Lotz
Editorial Director: Anne Yelland
Production: Jo Ryan, Cécile Lerbière

Printed and bound in China

9 8 7 6 5 4 3 2 1

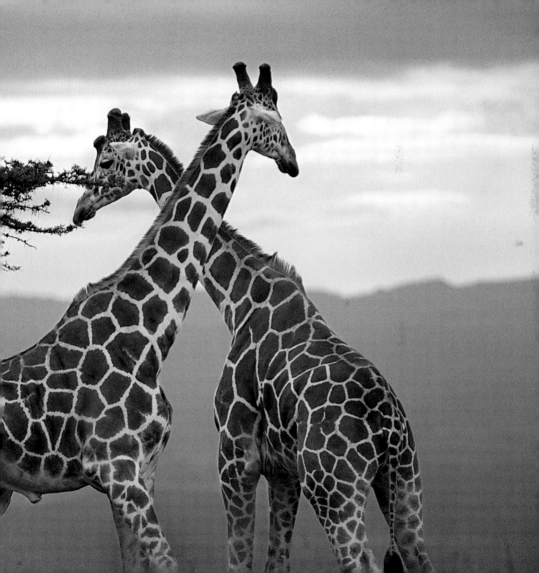

about this book

A beautifully designed collection of thoughts and sayings on love and what it means to finally find your soul mate, *Soul Mates* is an ideal gift for lovers to offer one another or for friends to give to couples as a keepsake. The words of wisdom and inspiration express the joy and happiness of falling in love, being in love, and staying in love. It is a book to treasure, to dip into when life is getting you down, and inspire you to share your love.

Complemented by evocative animal photographs, *Soul Mates* is a celebration of the enduring power of love.

about the author

Tom Burns has written for a range of magazines and edited more
than a hundred books on subjects such as games and sports,
cinema, history, and health and fitness. From the hundreds
of contributions that were sent to him by ordinary
people giving their real takes on life, he has selected
this collection that best defines what finding a life
partner really means.

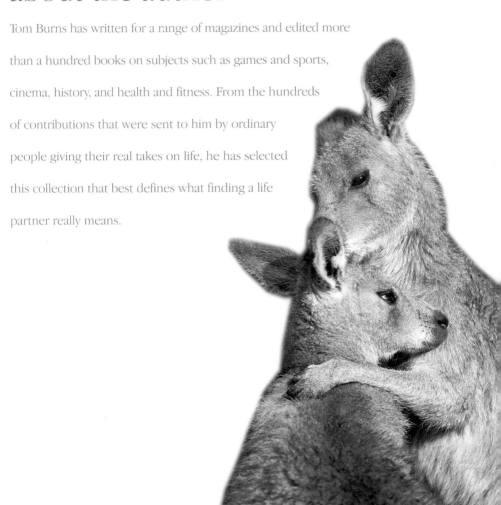

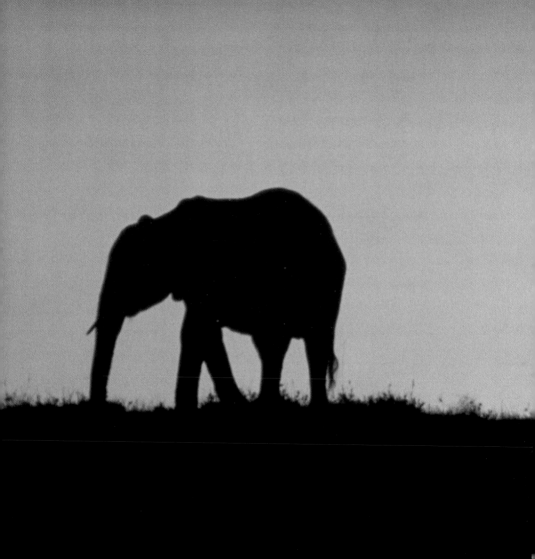

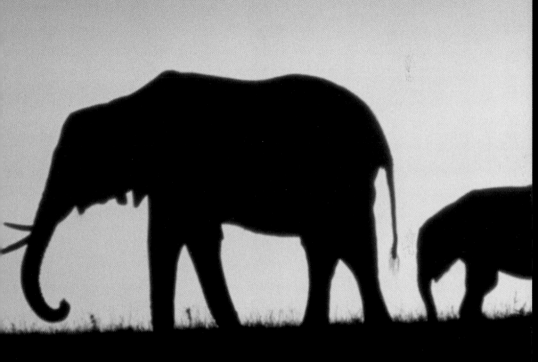

Love, like a river, cuts a new path when it meets an obstacle.

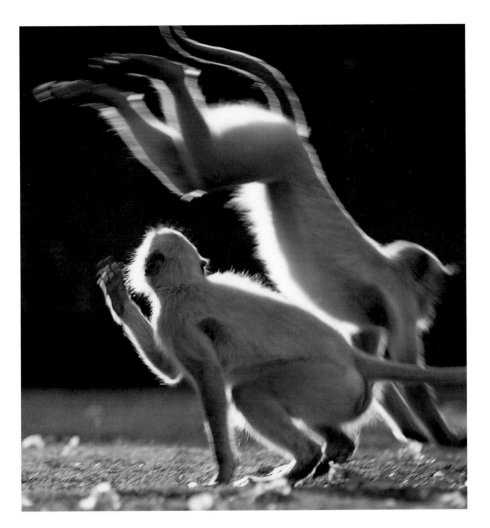

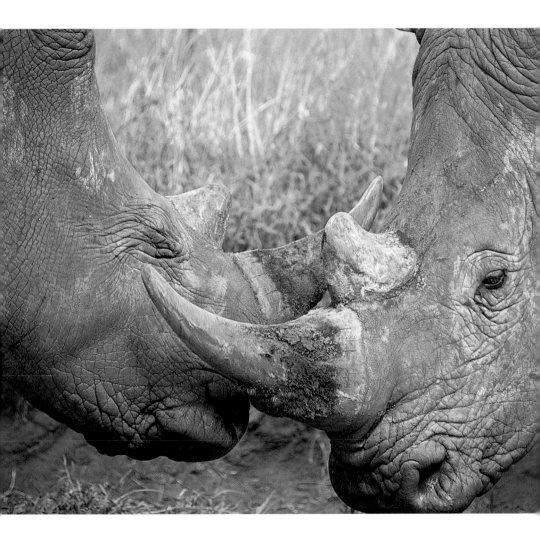

A lover's pact is the
most likely to last.

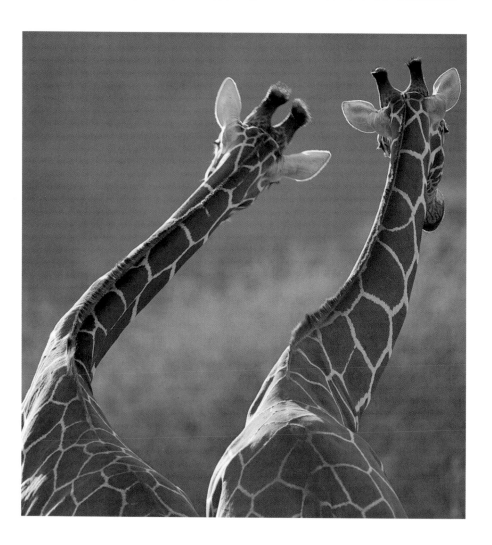

Love is like magic.

Passion elevates the soul to great things.

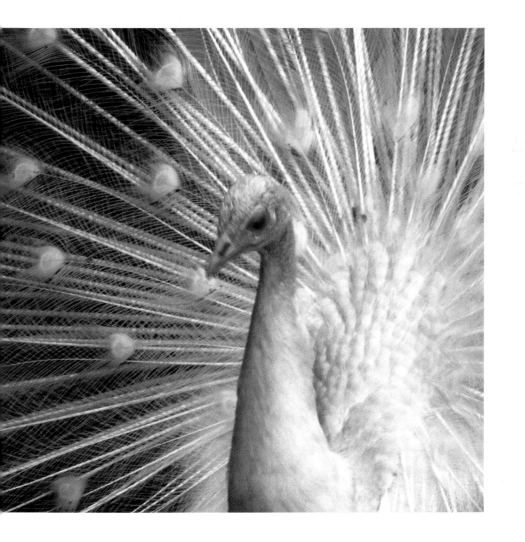

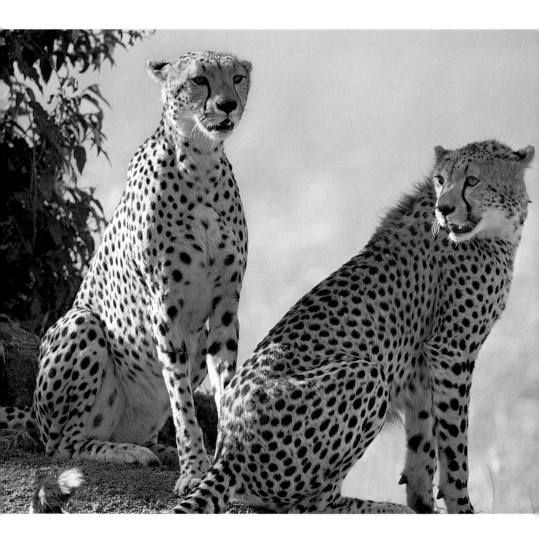

To be in love is to understand that love is strong yet delicate…

…for it can easily be broken.

When you fall in love
with someone, all your
wishes start coming true.

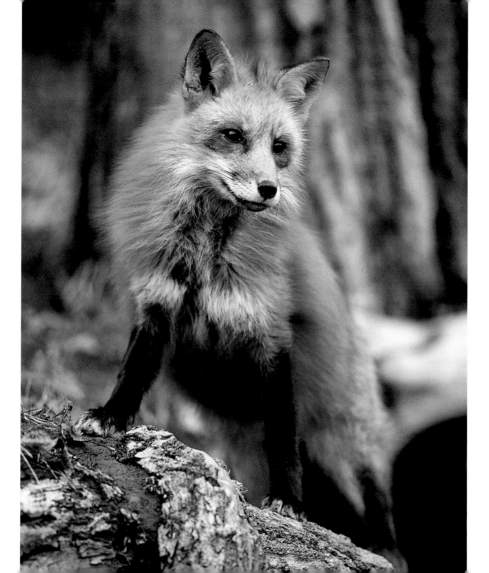

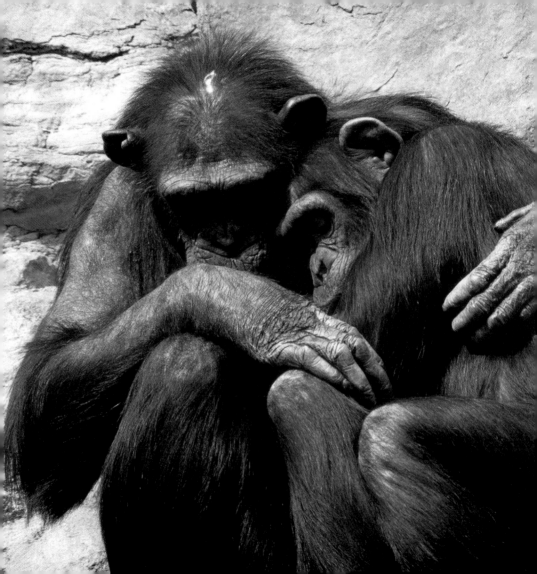

There is only one
happiness in life:
to love and to be loved.

Find the person who will love
you because of your differences
and not in spite of them, and you
have found a lover for life.

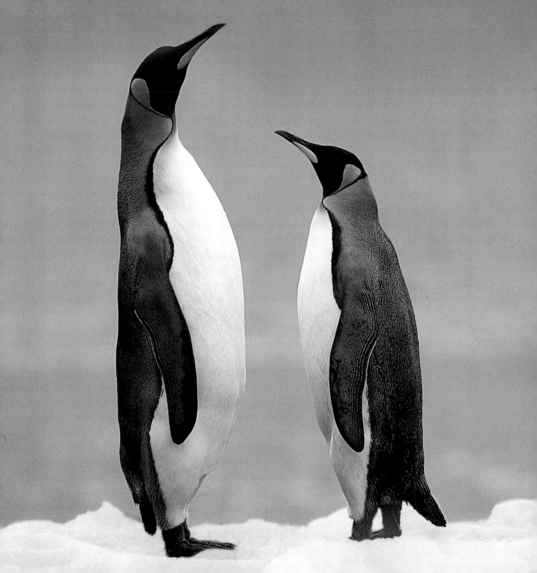

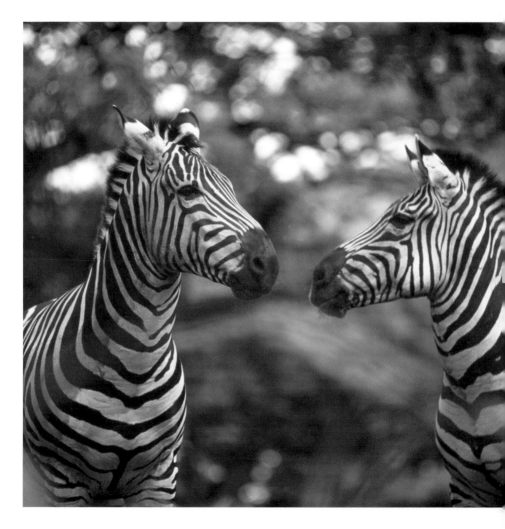

You know you are in love when you see the world in her eyes, and her eyes everywhere in the world.

We choose those we like;
with those we love, we have
no say in the matter.

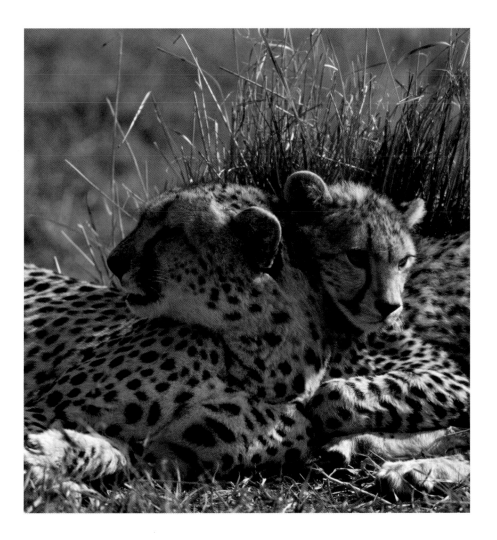

I love you not for who
you are, but who I am
when I am with you.

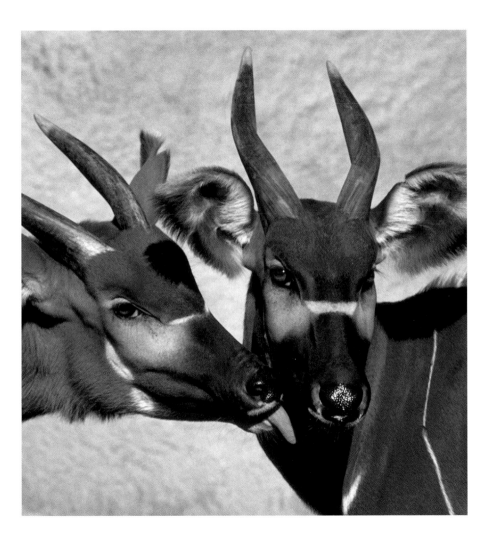

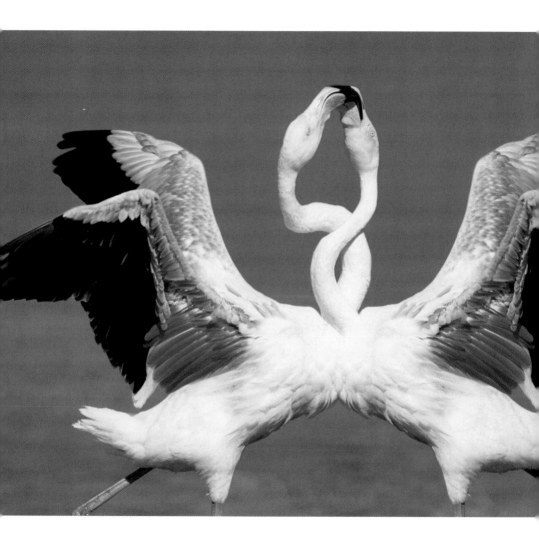

A soul mate has keys
that fit our locks and
locks that fit our keys.

The heart has reasons that the mind does not understand.

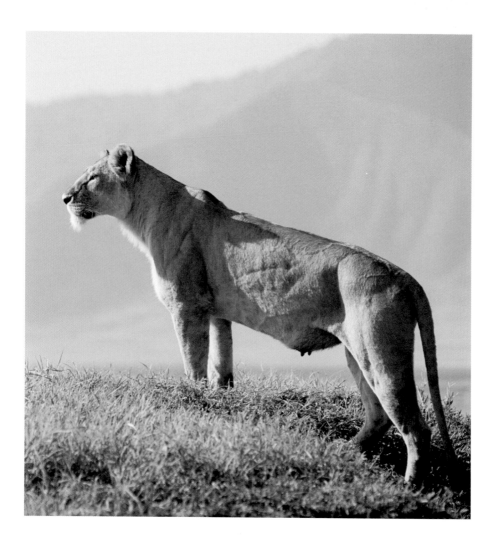

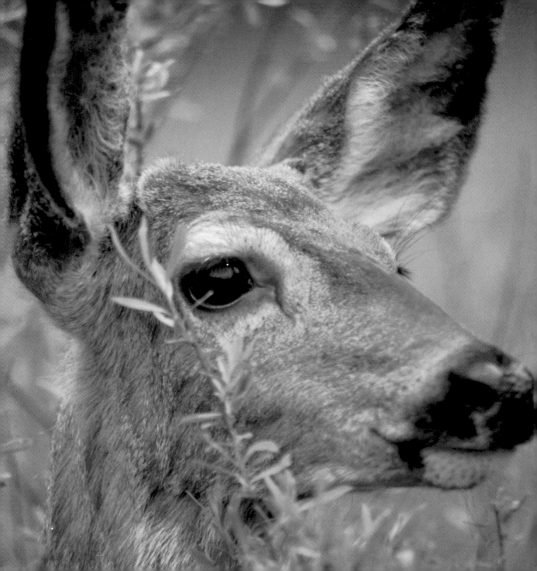

I love her for the
lust in her eyes.

Without passion, life is a bore.

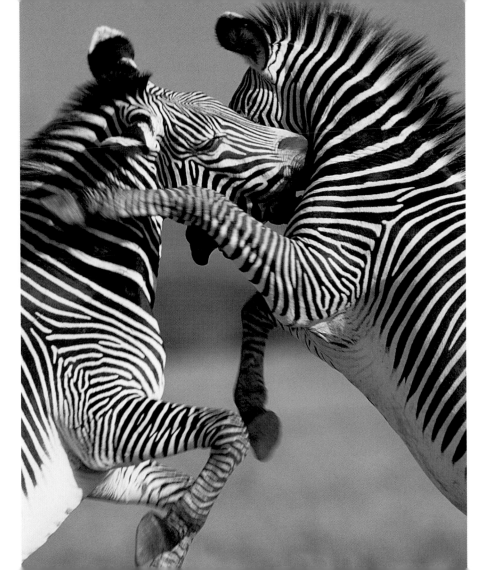

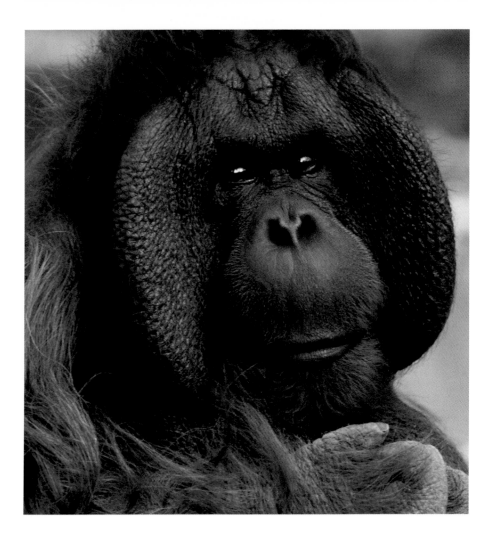

A hundred hearts could
not hold all my love for you.

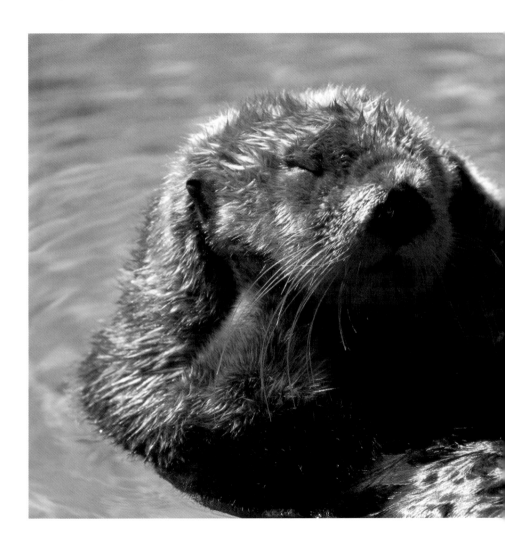

You can close your eyes
to what you do not want
to see, but you cannot
close your heart to what
you do not want to feel.

Kindness in words creates confidence. Kindness in thinking creates profoundness. Kindness in giving creates love.

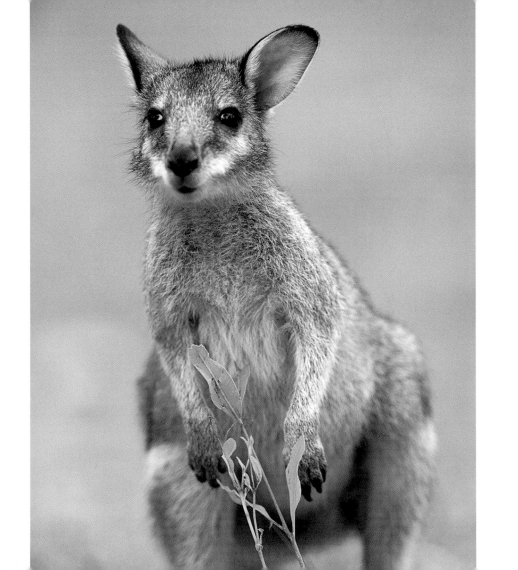

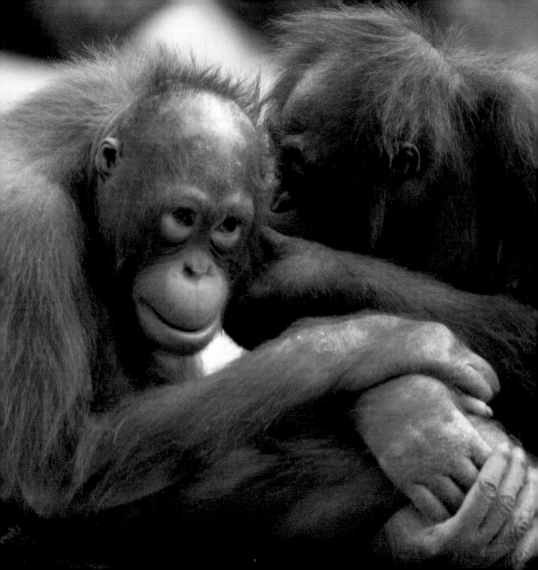

Love, like a lamp,
needs to be fed out of
the oil of another's heart,
or its flame burns low.

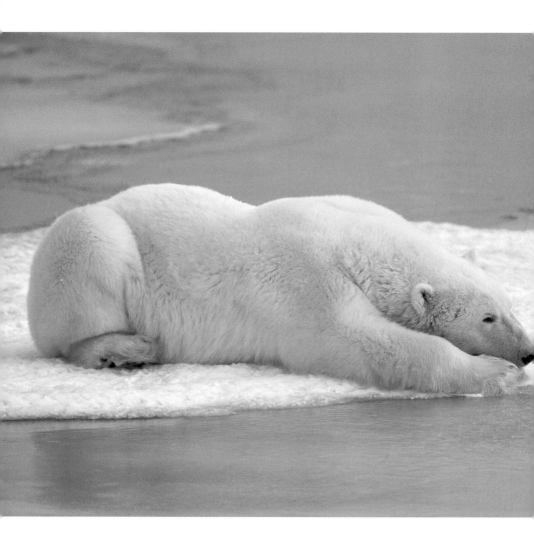

Love is an ocean
of emotions.

Passion does and
undoes everything.

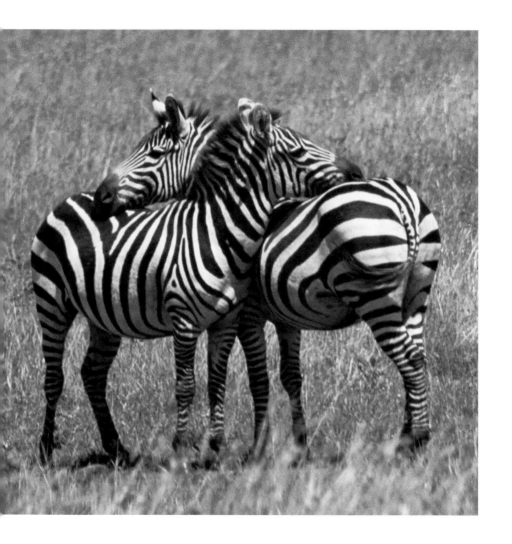

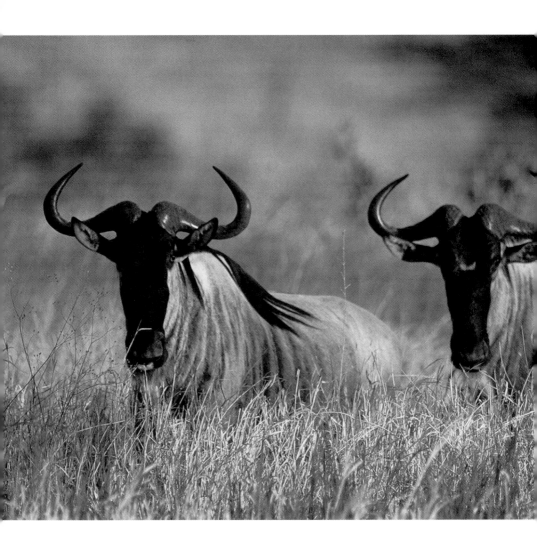

Love is a longing to be
with one special person.

Two souls at one
with silent memories.

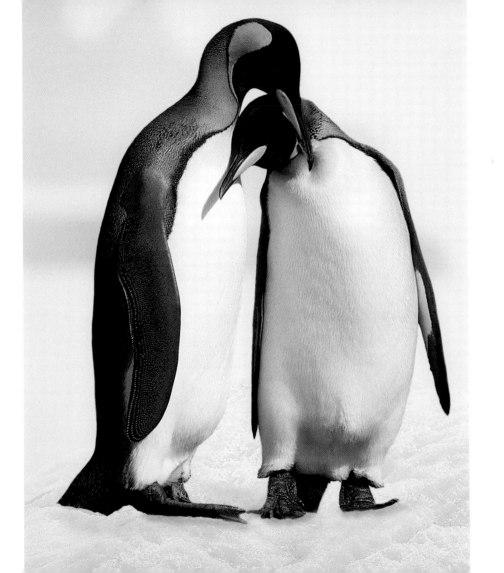

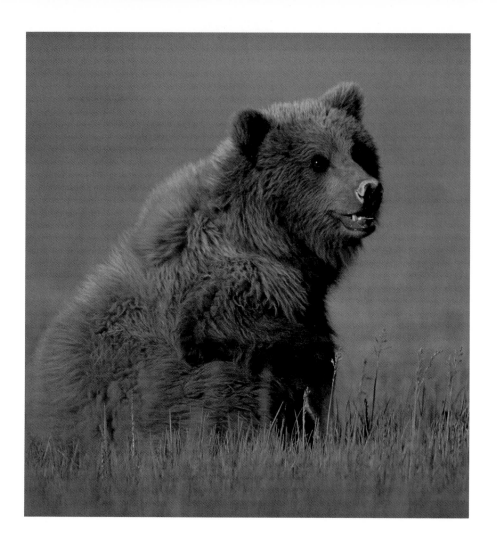

One plus one equals everything.
Two minus one equals nothing.

Love works in ways that are wondrous and strange.

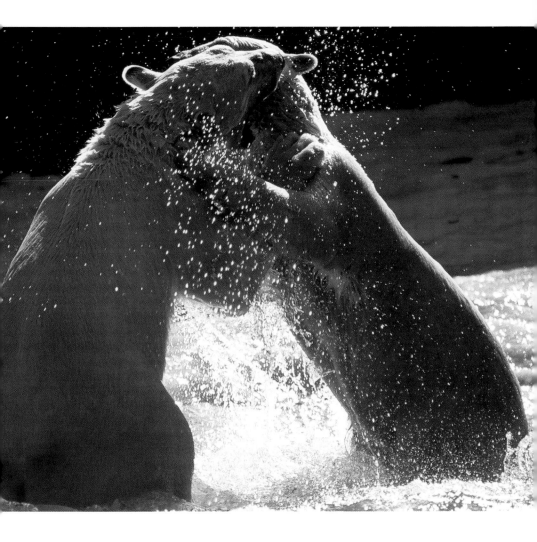

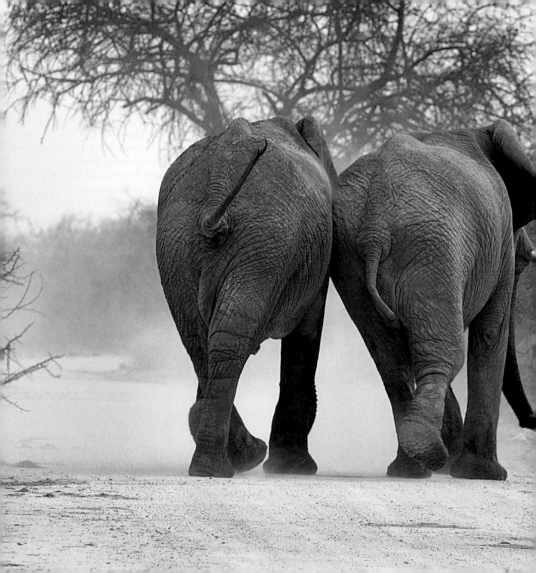

A soul mate shares
our deepest longings.

Love is a willingness
to give with no
expectation of receiving
anything in return.

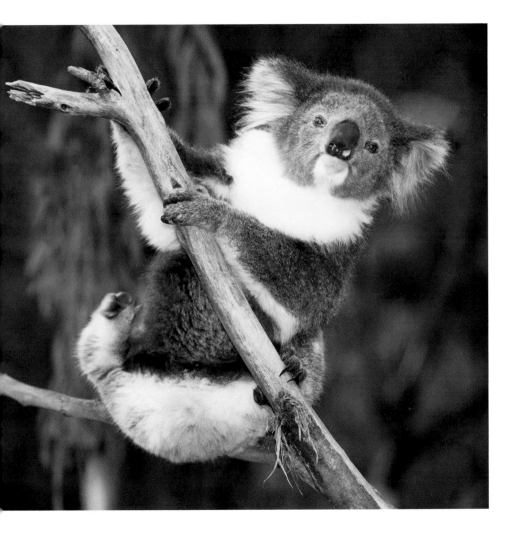

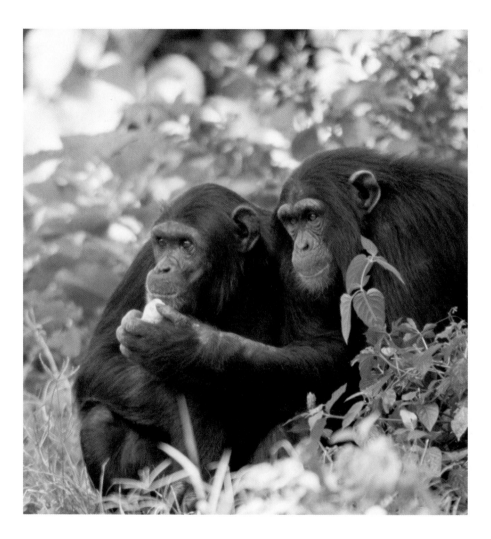

Soul mates, best friends, lovers…

…our hearts are now complete.

Falling in love isn't easy…

…but when you want to be
together despite anger and tears,
you know you have found
the right person.

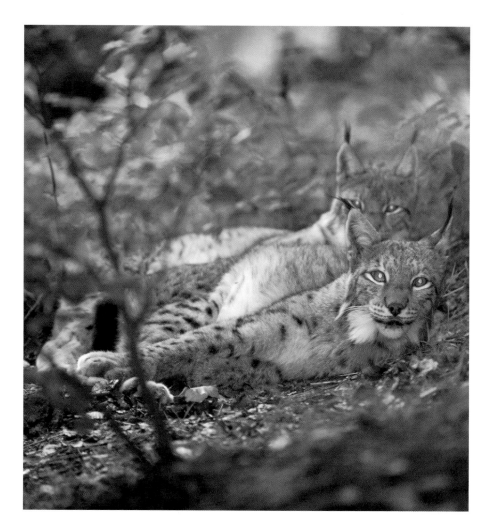

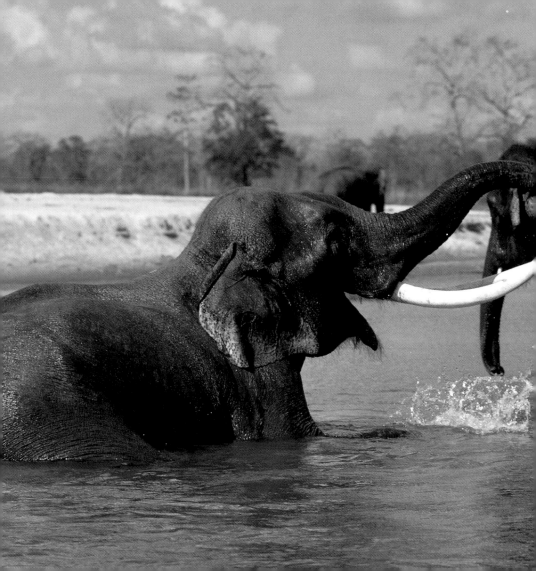

Your soul mate makes
love come to life.

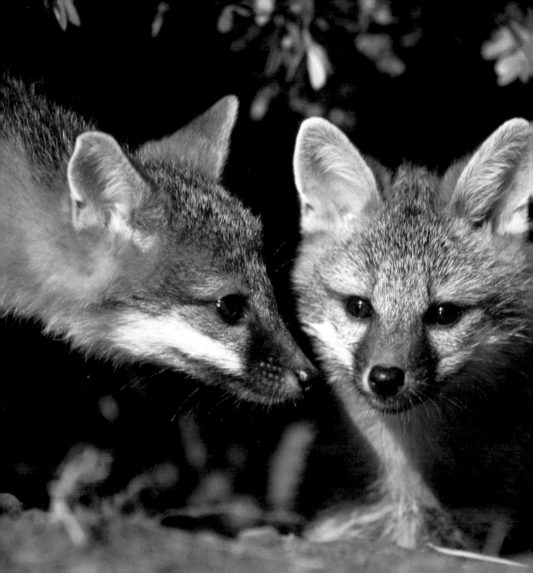

Love works
miracles every day.

There is no instinct
like that of the heart.

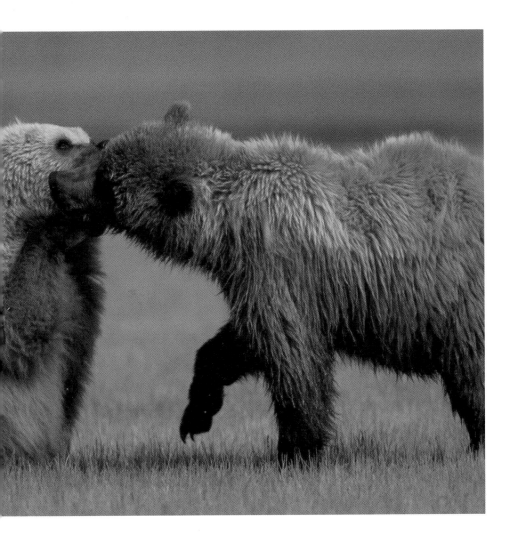

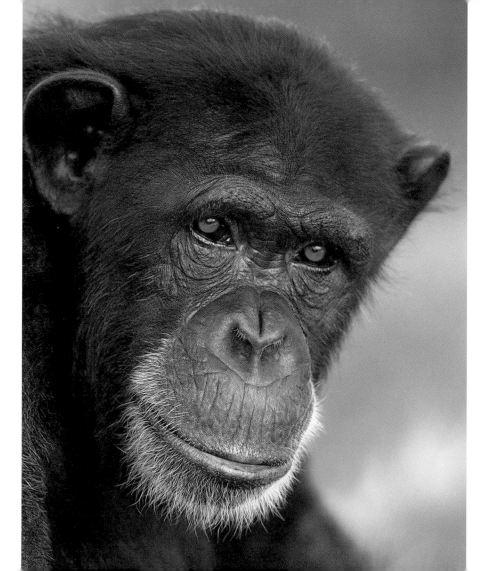

You like someone when you
learn what makes them laugh;
you love someone when you
learn what makes them cry.

Passion is much like a wild rose, beautiful and calm, but willing to draw blood in its defense.

Anyone can look into someone's eyes, but only lovers look into each other's souls.

Have a dream, and
use your power to
make it come true.

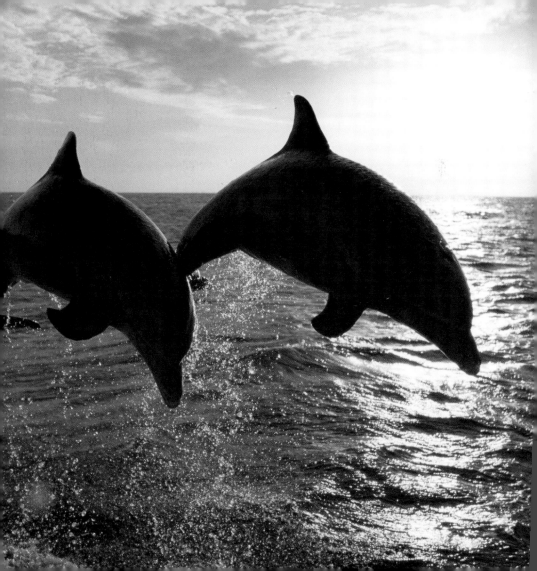

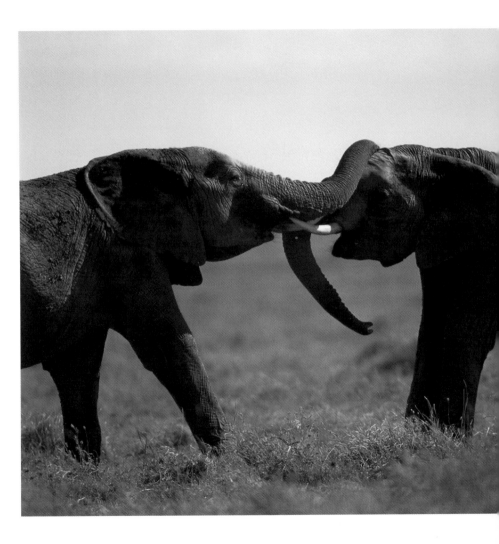

Soul mates love with
a love that is more
than love.

Soul mate, you unlock doors and open windows that I didn't even know were there.

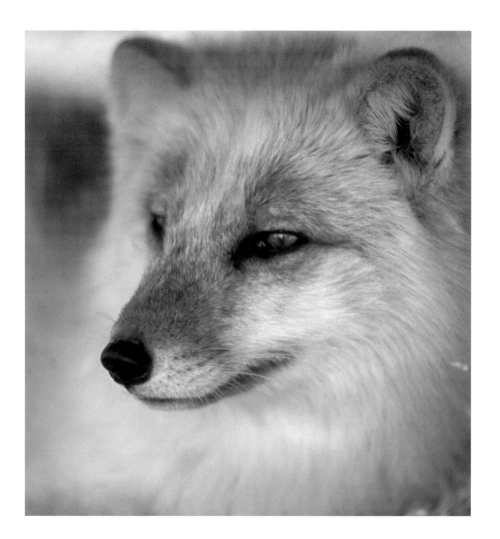

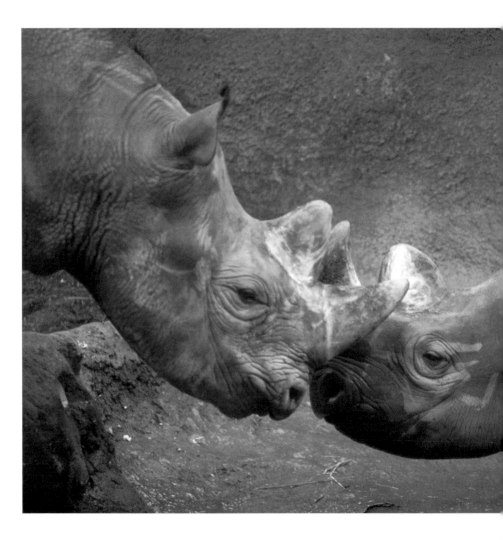

There is no greater thing
than for two souls
to feel they are joined.

Love is a sweet tyranny,
because the lover endures
the torment willingly.

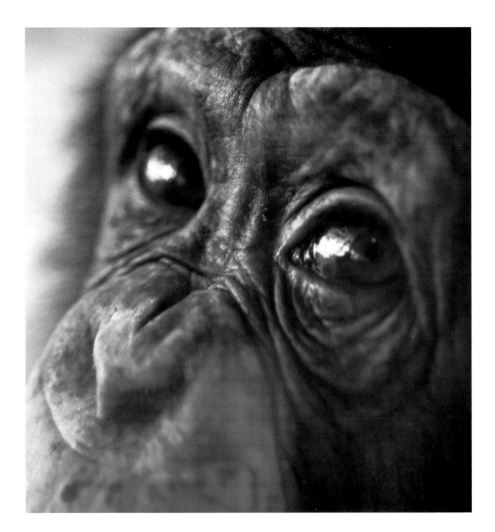

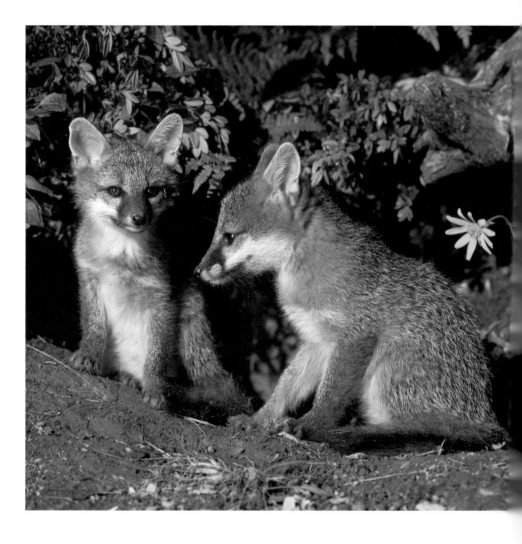

Don't waste time looking
for the perfect lover…

…spend time creating
the perfect love.

Love is a glimpse
of eternity.

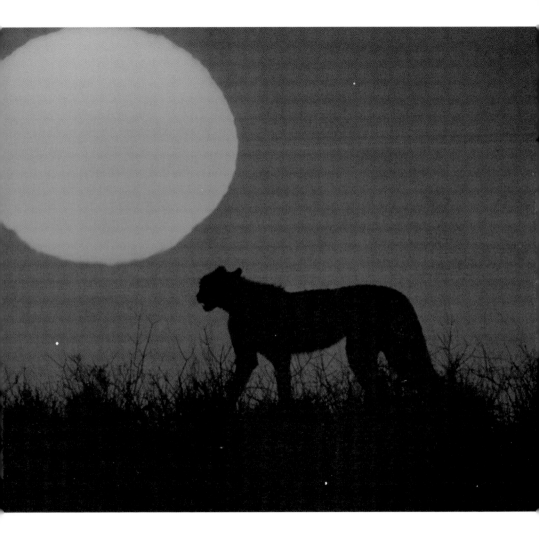

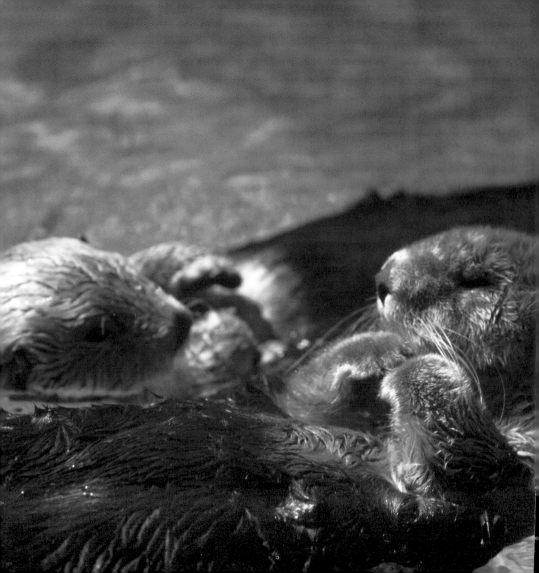

Let your love be like the misty rains, coming softly, but flooding the river.

Love is staying up all
night thinking of him…

…then falling asleep
and finding him in
your dreams.

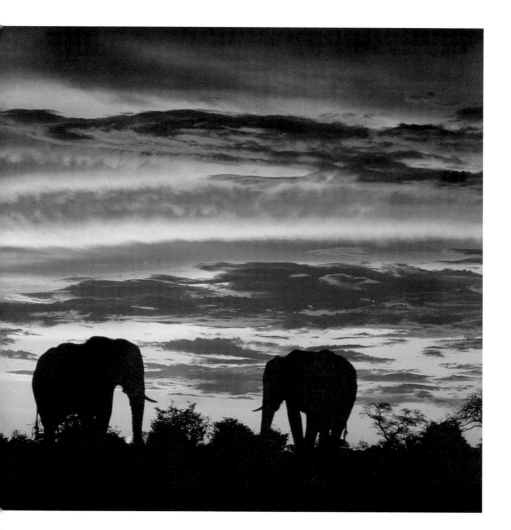

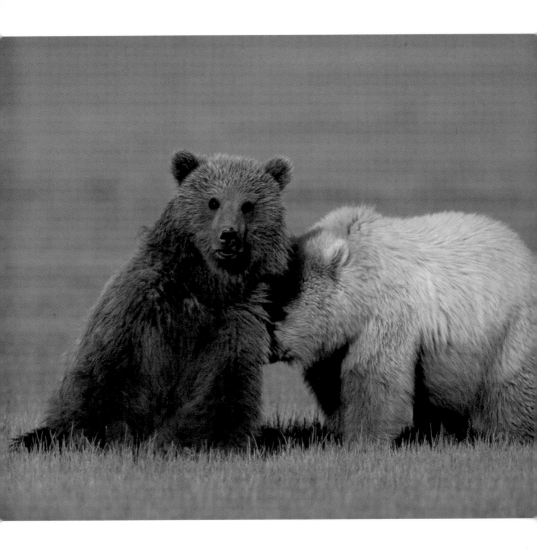

Don't wish to be
something to everyone…

…wish to be everything
to someone.

The soul gives unity to
what it looks at with love.

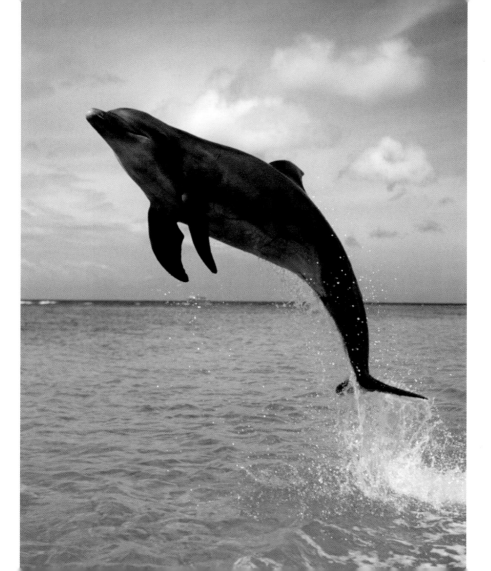

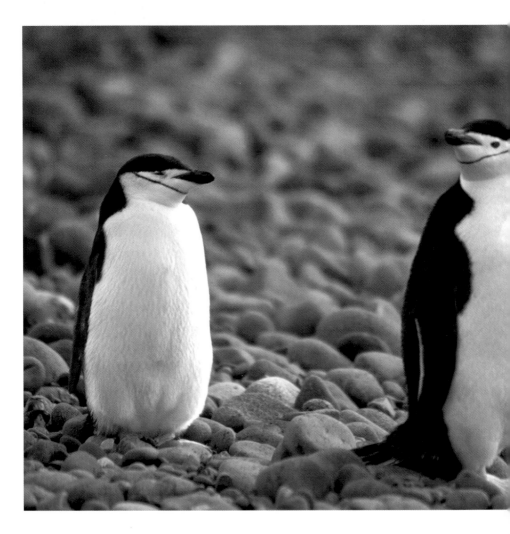

Meeting you was fate.
Becoming your friend was
choice. Falling in love with
you I couldn't control.

We can only learn
to love by loving.

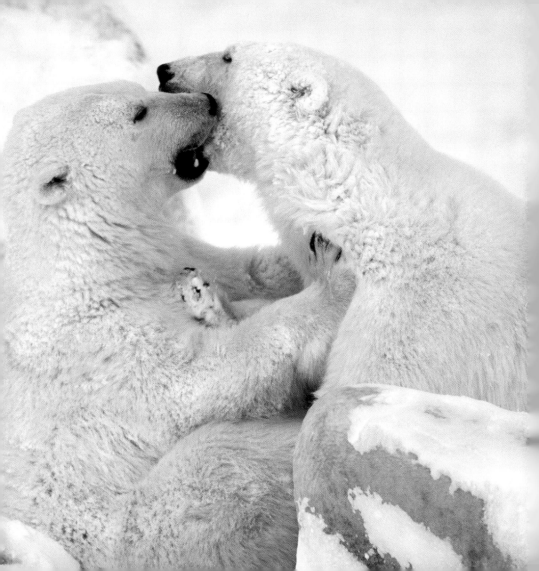

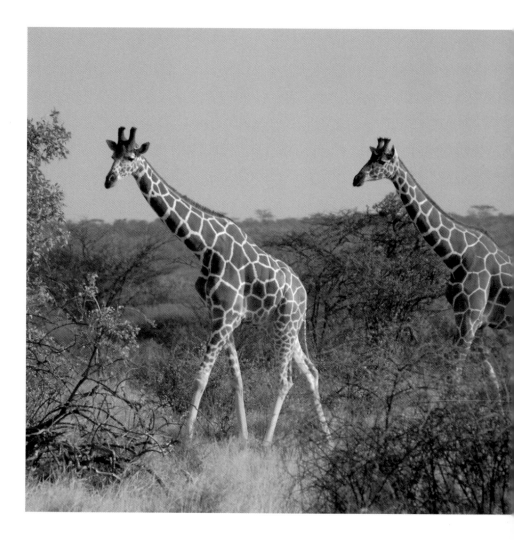

Follow your passion, and
success will follow you.

Love is the master key that
opens the gates of happiness.

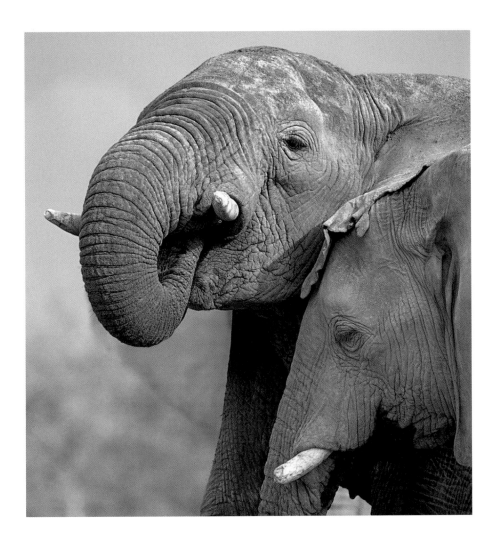

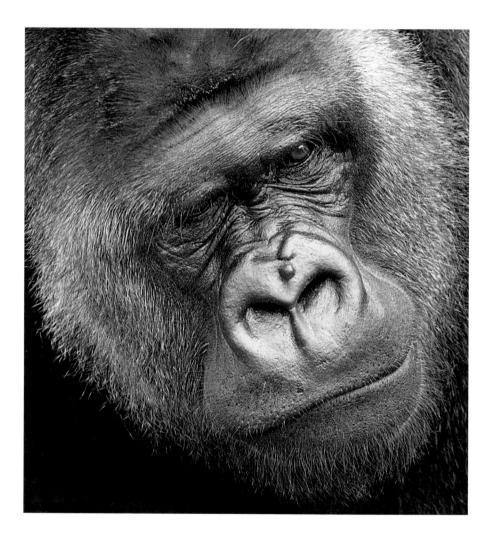

When love is not
madness, it is not love.

Love is missing someone when you're apart, but still feeling warm inside because you are close in heart.

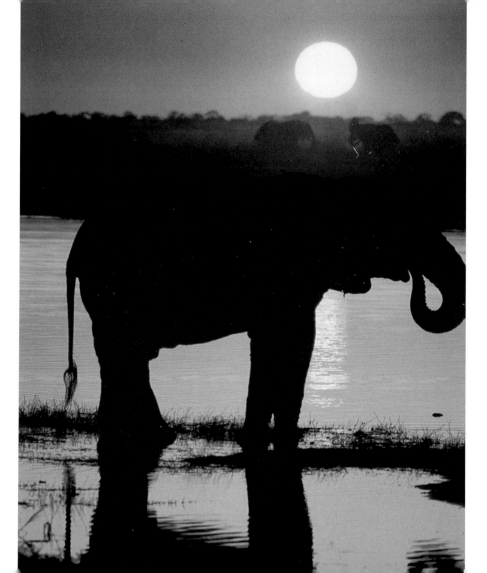

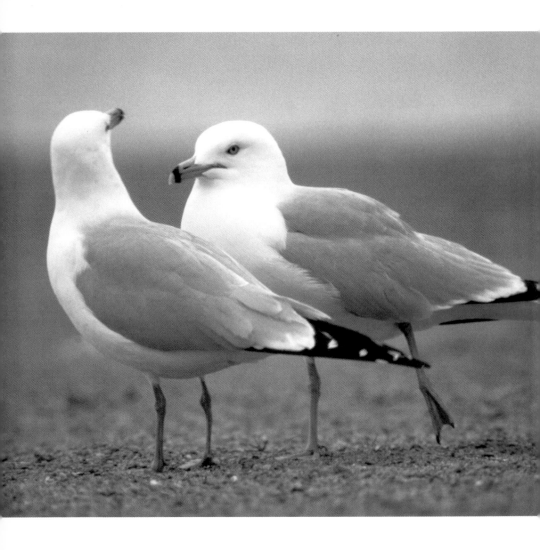

There is no feeling more comfortable than knowing you are right next to the person you should be with.

You know you are in love when you can't fall asleep because reality is better than your dreams.

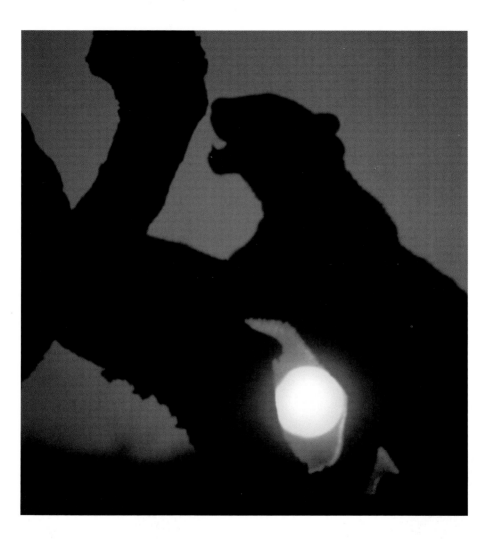

Love is the poetry of the senses.

The moments we really live for are those when we have done things in the spirit of love.

Love is an emblem of
eternity: it effaces the
memory of a beginning
and the fear of an end.

Passion makes
everyone beautiful.

Soul mates risk everything

for one another.

Two souls with a single thought…

…two hearts that beat as one.